THE BRITISH MUSEUM

FLOWERS

We are the sweet Flowers,
Born of sunny showers,
Think, whene'er you see us, what our beauty saith:
Utterance mute and bright
Of some unknown delight,
We fill the air with pleasure, by our simple breath:
All who see us, love us;
We befit all places;
Unto sorrow we give smiles, and unto graces, graces.

LEIGH HUNT (1784–1859)

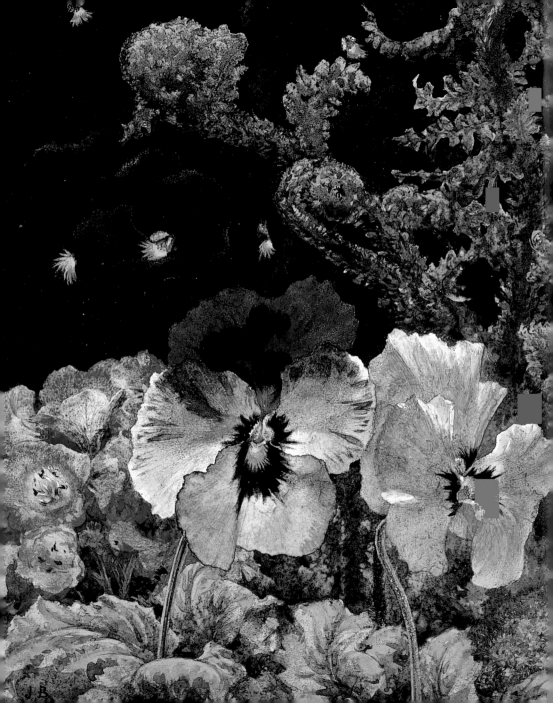

THE BRITISH MUSEUM
FLOWERS

EDITED BY

Marjorie Caygill

THE BRITISH MUSEUM PRESS

For Elsie, Mary, Annie and Mamie

© 2006 The Trustees of the British Museum
First published in 2006 by The British Museum Press
A division of The British Museum Company Ltd
38 Russell Square, London WC1B 3QQ

Marjorie Caygill has asserted her moral right to be identified
as the editor of this work

Photography by the British Museum Department of Photography and Imaging

A catalogue record for this book is available from the British Library

ISBN-13: 978-0-7141-5044-4

ISBN-10: 0-7141-5044-4

Frontispiece: John Brett (1831–1902), *Pansies and fern shoots*.
Watercolour, 1862.

Designed and typeset in Centaur by Peter Ward
Printed in China by C&C Offset Printing Co., Ltd

INTRODUCTION

LOWERS ARE EPHEMERAL, but their passing beauty can be captured by the artist or poet. Rabindranath Tagore's message across two centuries (1) echoes Chaucer's delight in fourteenth-century daisies (67); Holtzbecker's rose of 1660 (18) is as immediate as the unknown Mughal artist's profusion of flowers surrounding the portrait of Sháh Jahán (2).

The illustrations in this anthology are drawn from the extensive collections of the British Museum. The earliest dates from Egypt, over three millennia ago; the most recent from the 1990s. Because, in order to preserve them, they are rarely shown, the colours are often as fresh as when first painted. Texts and illustrations have been selected to complement each other. The Japanese poet Kano Morimasa Tanshin's 'Admiring the chrysanthemums' (80), for example, neatly illustrates Elizabeth Jennings's evocation of the scents of autumn (79). The powerful eighteenth-century thistle drawn by the German artist Margaretha Barbara Dietzsch (72) is a fitting accompaniment for Ted Hughes's twentieth-century poem (71).

Attitudes towards flowers vary between cultures. Wild flower pollen found concentrated around the head of a male skeleton from a Palaeolithic burial in Northern Iraq about 60,000 years ago suggests an ancient affinity. Western and Oriental poets and artists find flowers inspirational, but in Africa other plants and animals are preferred. In some parts of the world flowers are scarce or virtually non-existent and therefore do not appear prominently in art and poetry.

There are surprisingly few witty poems about flowers. Many poets confronted by petals descend into a lovesick gloom. Preferences vary: in Japan and China peonies and chrysanthemums are particularly popular; in Ancient Egypt the lotus is omnipresent. Western poets are inclined to favour roses, perhaps because they are regarded as particularly romantic.

It is hoped that, for its readers, this anthology, unlike Hoffenstein's fading blooms (47), will provide an enduring bouquet.

1. From *The Gardener*

Who are you, reader, reading my poems an hundred
years hence?
 I cannot send you one single flower from this
wealth of the spring, one single streak of gold
from yonder clouds.
 Open your doors and look abroad.
 From your blossoming garden gather fragrant
memories of the vanished flowers of an hundred years before.
 In the joy of your heart may you feel the living
joy that sang one spring morning, sending its
glad voice across an hundred years.

RABINDRANATH TAGORE (1861–1941)
India

2. Unknown artist, *Portrait of the Mughal emperor Sháh Jahán*.
Painting on paper, India (Mughal style), eighteenth century.

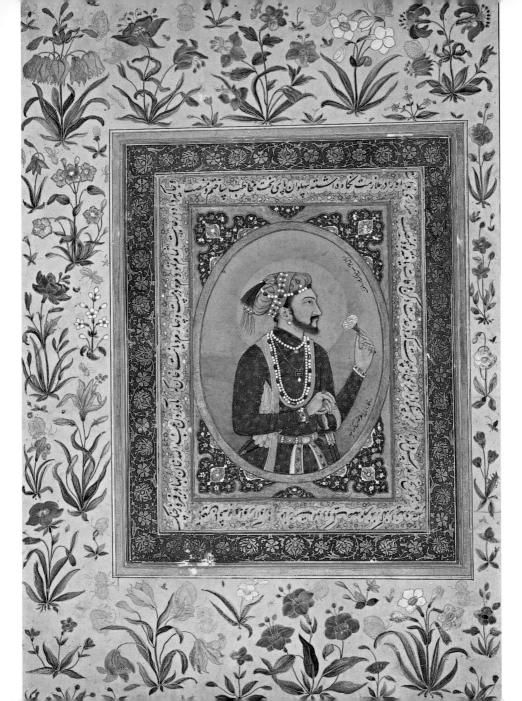

3. From *Much Ado About Nothing*

Hero. . . . And bid her steal into the pleached bower,
Where honey-suckles, ripen'd by the sun,
Forbid the sun to enter; like favourites,
Made proud by princes, that advance their pride
Against that power that bred it . . .

WILLIAM SHAKESPEARE (1564–1616)

4. Jacobus van Huysum (1687/9–1740),
Evergreen, Russian and English White Honeysuckle.
Watercolour, Netherlands.

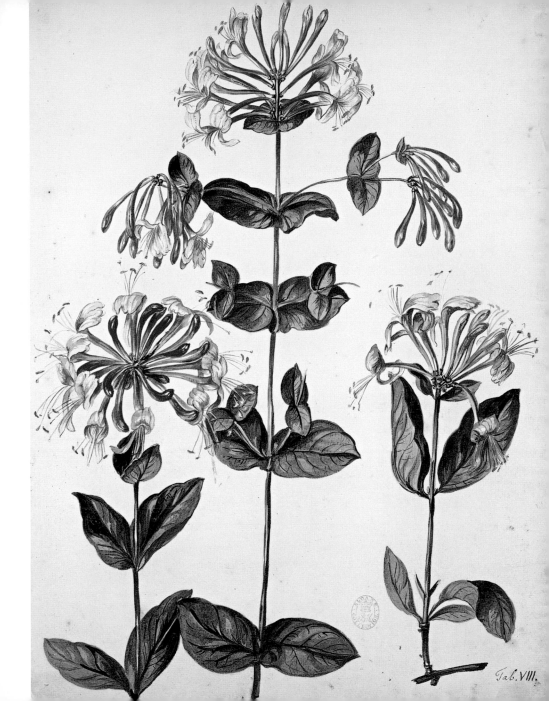

Tab. VIII.

5. *Iris*

a burst of iris so that
come down for
breakfast

we searched through the
rooms for
that

sweetest odor and at
first could not
find its

source then a blue as
of the sea
struck

startling us from among
those trumpeting
petals

WILLIAM CARLOS WILLIAMS (1883–1963)
USA

6. Jan van Huysum (1682–1749), *Iris germanica*.
Watercolour, Netherlands.

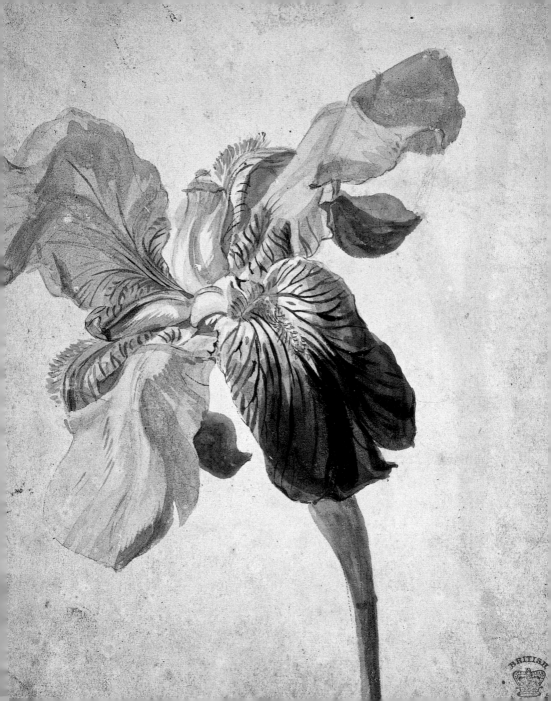

7. *Wiring Home*

Lest the wolves loose their whistles
and shopkeepers inquire,

keep moving; though your knees flush
red as two chapped apples,

keep moving; head up,
past the beggar's cold cup,

past fires banked under chestnuts
and the trumpeting kiosk's

tales of odyssey and heartbreak
until, turning a corner, you stand

staring: ambushed
by a window of canaries

bright as a thousand
golden narcissi.

RITA DOVE (b. 1952)
USA

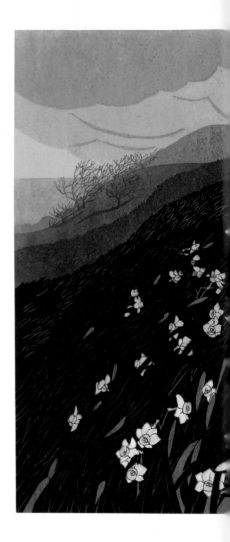

12

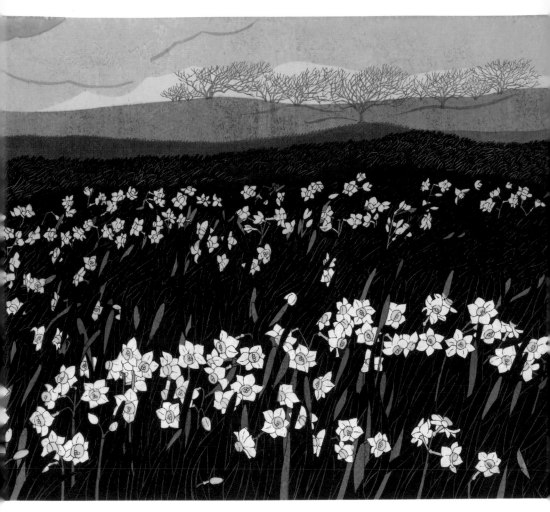

8. Kiyota Yuji, *Senka Koshun* (Narcissus, Calling Spring).
Colour woodblock, Japan, 1991.

9. *My Love is like a red, red rose*

O, my luve's like a red, red rose,
 That's newly-sprung in June:
O, my luve's like the melodie
 That's sweetly play'd in tune.

As fair art thou, my bonnie lass,
 So deep in luve am I:
And I will luve thee still, my dear,
 Till a' the seas gang dry.

Till a' the seas gang dry, my dear,
 And the rocks melt wi' the sun:
I will luve thee still, my dear,
 While the sands o' life shall run.

And fare thee weel, my only luve!
 And fare thee weel, a while!
And I will come again, my luve,
 Tho' it were ten thousand mile.

ROBERT BURNS (1759–96)

10. Jacques Le Moyne (*c.* 1533–88),
Rosa gallica (French rose) *and Privet Hawk Moth.*
Watercolour, France.

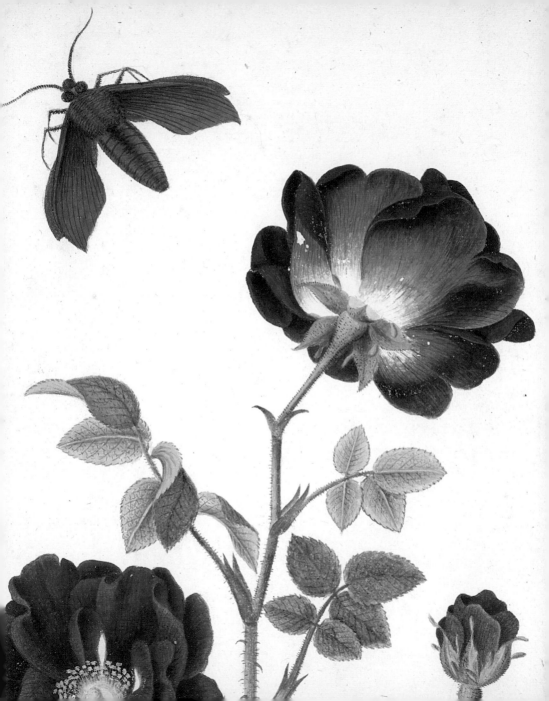

11. *The Troll's Nosegay*

A simple nosegay! was that much to ask?
(Winter still nagged, with scarce a bud yet showing.)
He loved her ill, if he resigned the task.
'Somewhere,' she cried, 'there must be blossom blowing.'
It seems my lady wept and the troll swore
By Heaven he hated tears: he'd cure her spleen —
Where she had begged one flower he'd shower fourscore,
A bunch fit to amaze a China Queen.

Cold fog-drawn Lily, pale mist-magic Rose
He conjured, and in a glassy cauldron set
With elvish unsubstantial Mignonette
And such vague blooms as wandering dreams enclose.
But she?
 Awed.
 Charmed to tears,
 Distracted,
 Yet –
Even yet, perhaps, a trifle piqued – who knows?

ROBERT GRAVES (1895–1985)

12. Odilon Redon (1840–1916), *Tête d'enfant*
(A Boy's head and a flying bouquet of flowers).
Lithograph on chine appliqué, France, 1900.

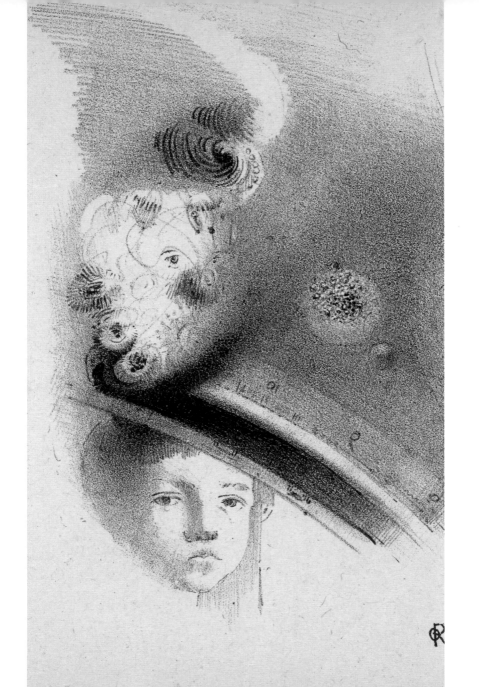

13. *The Snowdrop*

Many, many welcomes
February fair-maid,
Ever as of old time,
Solitary firstling,
Coming in the cold time,
Prophet of the gay time,
Prophet of the May time,
Prophet of the roses,
Many, many welcomes
February fair-maid!

ALFRED, LORD TENNYSON (1809–92)

14. Mary Delany (1700–88), *Double snowdrop*.
Paper collage, 1775.

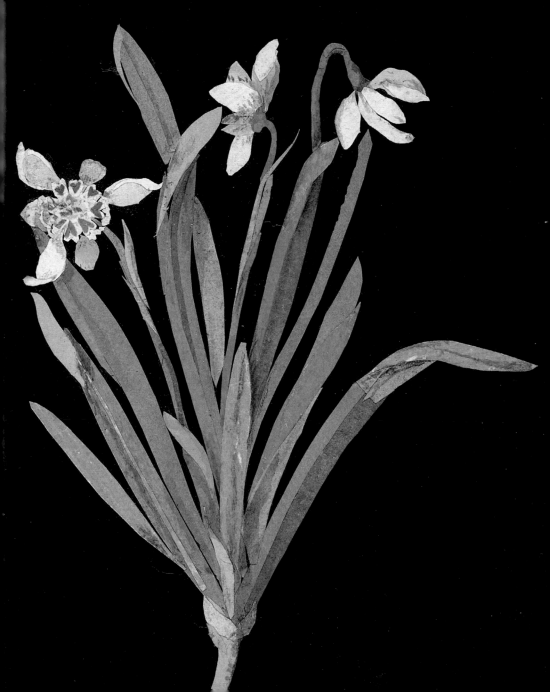

15. *Bossy and the Daisy*

Right up into Bossy's eyes,
 Looked the Daisy, boldly,
But, alas! to his surprise,
 Bossy ate him, coldly.

Listen! Daisies in the fields,
 Hide away from Bossy!
Daisies make the milk she yields,
 And her coat grow glossy!

So, each day, she tries to find
 Daisies nodding sweetly,
And although it's most unkind,
 Bites their heads off, neatly!

MARGARET DELAND (1857–1945)
USA

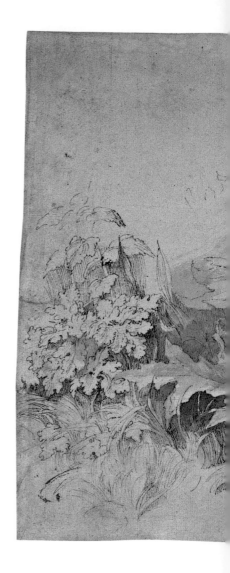

16. Anthony van Dyck (1599–1641),
*Study of Plants. A sow-thistle with nettles
and sketches of a trefoil, daisy and fern.*
Pen and brown ink, with grey-brown wash,
Flemish/British, *c.* 1632–41.

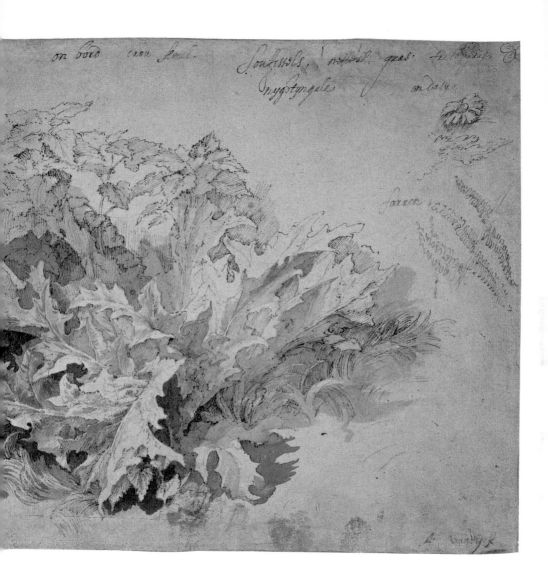

17. *One Perfect Rose*

A single flow'r he sent me, since we met.
　　All tenderly his messenger he chose;
Deep-hearted, pure, with scented dew still wet –
　　One perfect rose.

I knew the language of the floweret;
　　"My fragile leaves," it said, "his heart enclose."
Love long has taken for his amulet
　　One perfect rose.

Why is it no one ever sent me yet
　　One perfect limousine, do you suppose?
Ah no, it's always just my luck to get
　　One perfect rose.

Dorothy Parker (1893–1967)
USA

18. Hans Simon Holtzbecker (d. 1671), *Roses* (detail).
Watercolour, Germany, 1660.

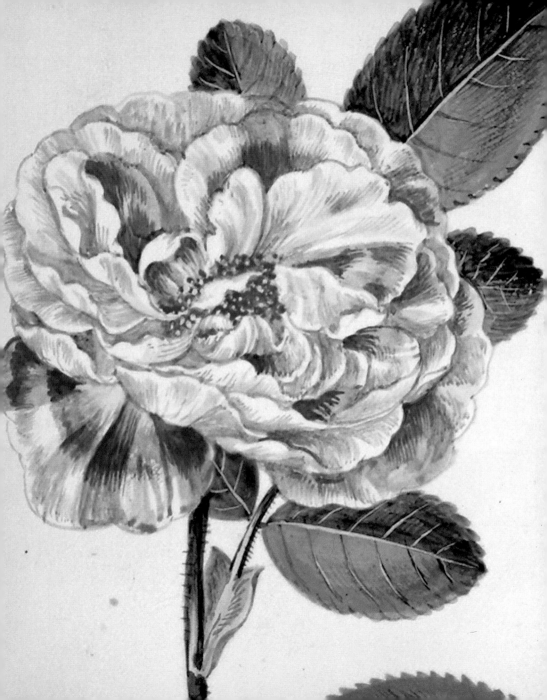

19. From *Songs and Chorus of the Flowers: Poppies*

We are slumberous poppies,
 Lords of Lethe downs,
Some awake, and some asleep,
 Sleeping in our crowns.
What perchance our dreams may know,
Let our serious beauty show.

Central depth of purple,
 Leaves more bright than rose,
Who shall tell what brightest thought
 Out of darkest grows?
Who, through what funereal pain
Souls to love and peace attain?

Visions aye are on us,
 Unto eyes of power,
Pluto's always setting sun,
 And Prosérpine's bower:
There, like bees, the pale souls come
For our drink with drowsy hum.

Taste, ye mortals, also;
 Milky-hearted, we;
Taste, but with a reverent care;
 Active-patient be.
Too much gladness brings to gloom
Those who on the gods presume.

Leigh Hunt (1784–1859)

20. Mary Delany (1700–88),
Opium Poppy. Paper collage, 1776.

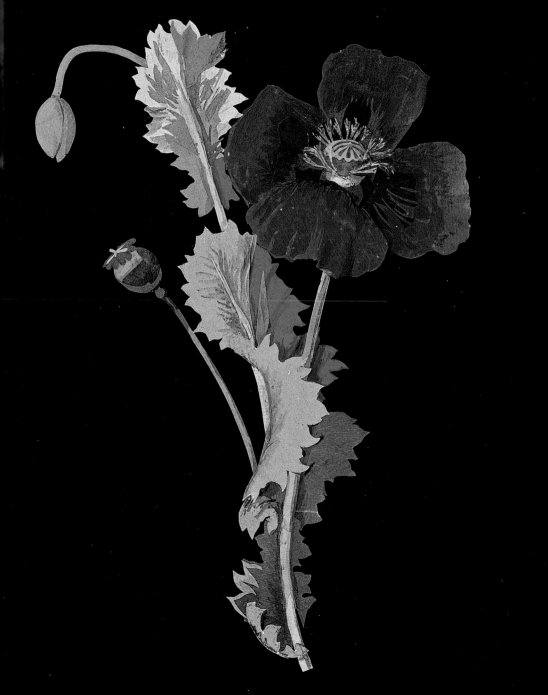

21. *Sonnet*

Is there a great green commonwealth of Thought
Which ranks the yearly pageant, and decides
How Summer's royal progress shall be wrought,
By secret stir which in each plant abides?
Does rocking daffodil consent that she,
The snowdrop of wet winters, shall be first?
Does spotted cowslip with the grass agree
To hold her pride before the rattle burst?
And in the hedge what quick agreement goes,
When hawthorn blossoms redden to decay,
That Summer's pride shall come, the Summer's rose,
Before the flower be on the bramble spray?
Or is it, as with us, unresting strife,
And each consent a lucky gasp for life?

JOHN MASEFIELD (1878–1967)

22. Albrecht Dürer (1471–1528),
Lily of the valley and bugle. Brush drawing strengthened
with pen and brown ink, Germany.

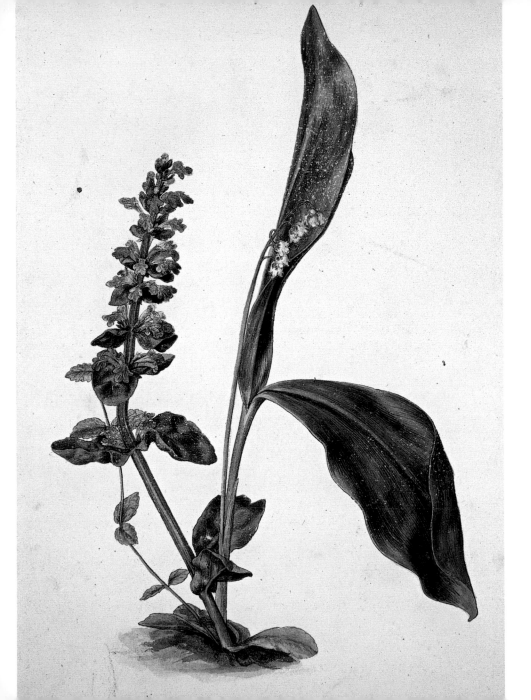

23. *Calcutta*

The warm afternoon sheds gladness
Over the long leaves across the fence.
Above the cunningly patterned gate
A bunch of honeysuckle waves in the joyous wind.
I pass on the road, with this delicate scene in my eyes.
Someone's careless leisure.
Replete with the piano's faint music,
Strikes the golden sky:
Calcutta's southern lane.

If ever I return to earth
Again on this road I shall pass,
Watching, in the caressing sunlight,
The red canna by the gate,
The garden flowers, yellow and freshly blue,
The grass carpet, in whose green depths
The eye loses itself.
I shall never know whose home it is.
The longing of spring, which is pain,
The piano-playing leisure
Will touch for a moment the traveller's barren heart.
The tall, calm trees,
A gentle hour . . .
And across the fence
I shall pass, knowing the mind's world as joy.

Amiya Chakravarty (1901–86),
translated by S. Chakravarty and S. Dasgupta
India

24. Unknown artist, *Radha and Krishna in a garden with musicians and attendants.*
Painting on paper, India (Pahari School, Kangra style), *c.* 1840.

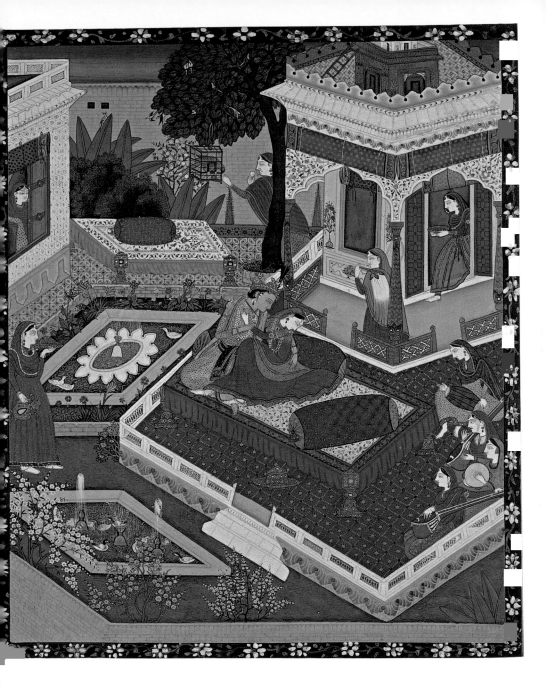

25. *The Lilies of the Field*

And why take ye thought for raiment? Consider the lilies of the field, how they grow; they toil not, neither do they spin:

And yet I say unto you, That even Solomon in all his glory was not arrayed like one of these.

Wherefore, if God so clothe the grass of the field, which to day is, and to morrow is cast into the oven, *shall he* not much more *clothe* you, O ye of little faith?

THE BIBLE

26. Jacobus van Huysum (1687/9–1740),
Striped white lily (Lilium candidum).
Watercolour, Netherlands.

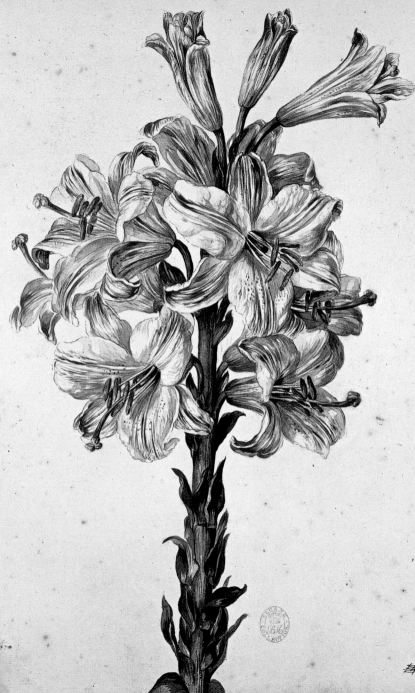

27. *A Persian Love Poem*

We celebrate the New Year's Feast but once in all the year;
A Feast perpetual to me affords thy presence dear.
One day the roses hang in clusters thick upon the tree;
A never-failing crop of roses yield thy cheeks to me.
One day I gather violets by the bunch in gardens fair,
But violets by the sheaf are yielded by thy fragrant hair.
The wild narcissus for a single week the field adorns;
The bright narcissus of thine eye outlasts three hundred morns.
The wild narcissus must its freshness lose or vigil keep:
To thy narcissus-eyes no difference waking makes or sleep.
Fragrant and fair the garden jasmine is in days of Spring,
But round thy hyacinths the jasmine-scent doth ever cling.
Nay, surely from thy curls the hyacinths their perfume stole,
These are the druggist's stock-in-trade and those food for the soul.
Those from a ground of silver spring, and these from heaps of stone;
Those crown a cypress-form, while these adorn some upland lone.
There is a garden-cypress which remains for ever green,
Yet by thy cypress-stature it appears uncouth and mean.

Imámí of Herát (d. 1268/9)
translated by Edward G. Browne (1862–1926)
Afghanistan

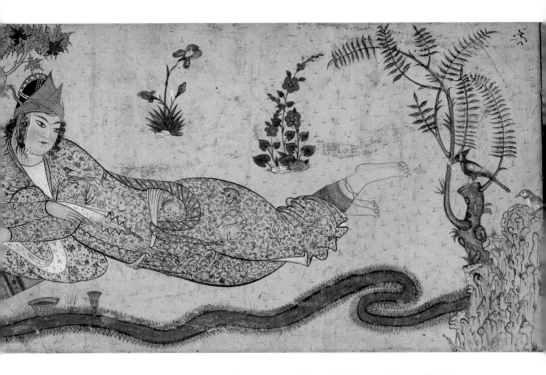

28. *Bilqis, Queen of Sheba, and the hoopoe who carried her love letters to King Solomon.* Painting on paper, Safavid Iran, *c.* 1590.

29. *The Flowers*

All the names I know from nurse:
Gardener's garters, Shepherd's purse,
Bachelor's buttons, Lady's smock,
And the Lady Hollyhock.

Fairy places, fairy things,
Fairy woods where the wild bee wings,
Tiny trees for tiny dames –
These must all be fairy names!

Tiny woods below whose boughs
Shady fairies weave a house;
Tiny tree-tops, rose or thyme,
Where the braver fairies climb!

Fair are grown-up people's trees,
But the fairest woods are these;
Where if I were not so tall,
I should live for good and all.

Robert Louis Stevenson (1850–94)

30. Jacques Le Moyne (*c*. 1533–88),
Hollyhock (Alcea rosa).
Watercolour, France.

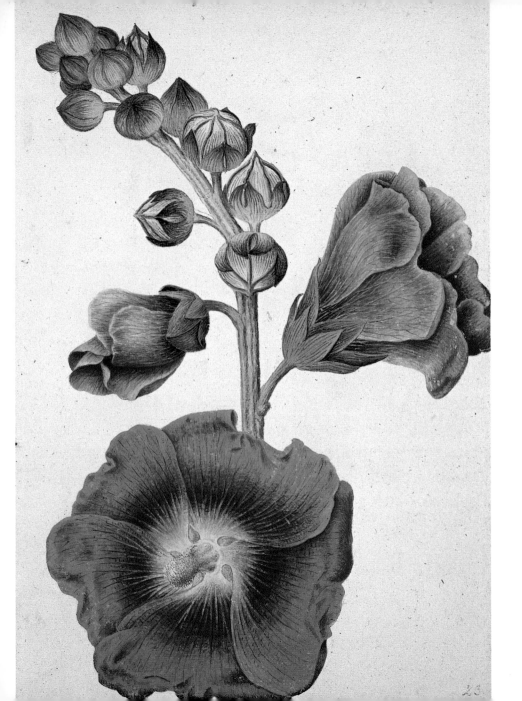

31. From *A Midsummer-Night's Dream*

Puck. How now, spirit!
whither wander you?
Fairy. Over hill, over dale,
 Thorough bush, thorough brier,
 Over park, over pale,
 Thorough flood, thorough fire,
 I do wander every where,
 Swifter than the moone's sphere;
 And I serve the fairy queen,
 To dew her orbs upon the green:
 The cowslips tall her pensioners be;
 In their gold coats spots you see;
 Those be rubies, fairy favours,
 In their freckles live their savours:
I must go seek some dew-drops here,
And hang a pearl in every cowslip's ear.

WILLIAM SHAKESPEARE (1564–1616)

32. Mary Delany (1700–88), *Cowslip*.
Paper collage, 1775.

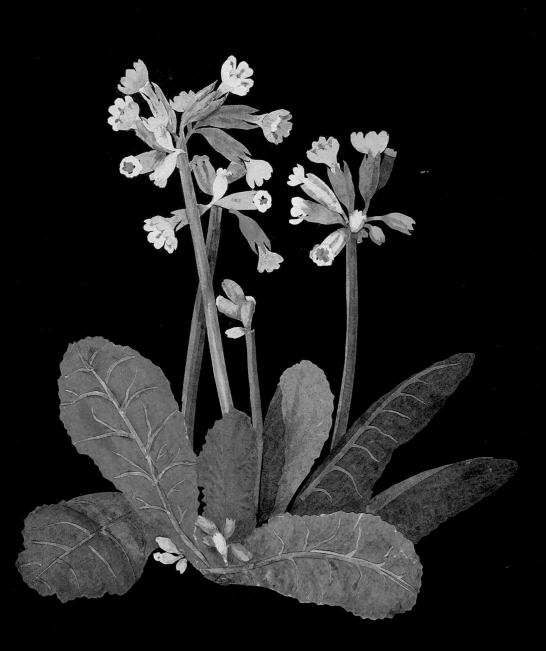

33. A Garden Song

I scorn the doubts and cares that hurt
 The world and all its mockeries,
My only care is now to squirt
 The ferns among my rockeries.

In early youth and later life
 I've seen an up and seen a down,
And now I have a loving wife
 To help me peg verbena down.

Of joys that come to womankind
 The loom of fate doth weave her few,
But here are summer joys entwined
 And bound with golden feverfew,

I've learnt the lessons one and all
 With which the world its sermon stocks,
Now, heedless of a rise or fall,
 I've Brompton and I've German stocks.

In peace and quiet pass our days,
 With nought to vex our craniums,
Our middle beds are all ablaze
 With red and white geraniums.

And like a boy I laugh when she,
 In Varden hat and Varden hose,
Comes slyly up the lawn at me
 To squirt me with the garden hose.

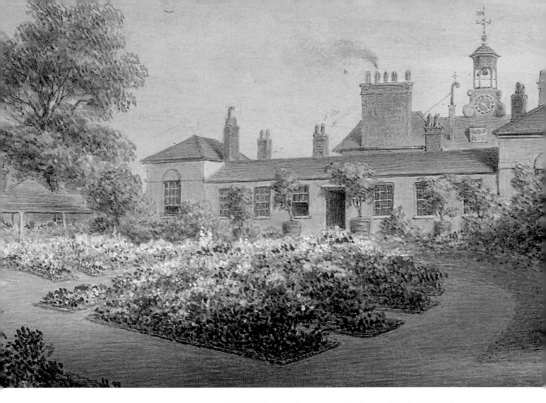

34. J.G.P. Fischer (1786–1875), *Queen Charlotte's Garden,
Buckingham House* (detail). Watercolour, 1810.

Let him who'd have the peace he needs
 Give all his worldly mumming up,
Then dig a garden, plant the seeds,
 And watch the product coming up.

GEORGE R. SIMS (1847–1922)

35. *Celandine*

Thinking of her had saddened me at first,
Until I saw the sun on the celandines lie
Redoubled, and she stood up like a flame,
A living thing, not what before I nursed,
The shadow I was growing to love almost,
The phantom, not the creature with bright eye
That I had thought never to see, once lost.

She found the celandines of February
Always before us all. Her nature and name
Were like those flowers, and now immediately
For a short swift eternity back she came,
Beautiful, happy, simply as when she wore
Her brightest bloom among the winter hues
Of all the world; and I was happy too,
Seeing the blossoms and the maiden who
Had seen them with me Februarys before,
Bending to them as in and out she trod
And laughed, with locks sweeping the mossy sod.

But this was a dream: the flowers were not true,
Until I stooped to pluck from the grass there
One of five petals and I smelt the juice
Which made me sigh, remembering she was no more,
Gone like a never perfectly recalled air.

EDWARD THOMAS (1878–1917)

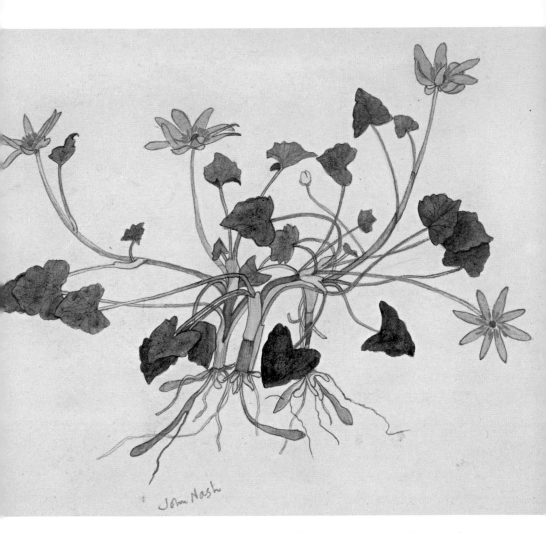

36. John Northcote Nash (1893–1977),
Lesser celandine (or pilewort). Watercolour, 1915.



41

37. *Tulipomania*

Tulips first appeared in Western Europe, from Turkey, in the sixteenth century AD.

At first largely of interest to connoisseurs and scholars, they became popular amongst speculators, leading to a trading mania in the Netherlands between 1634 and 1637, when dealing in tulip bulbs was suspended. In a sale of ninety-nine lots of bulbs at Alkmaar in February 1637, for example, the average price per bulb represented about two years pay for a master carpenter in Leiden. This one sale realised a total of 90,000 guilders, perhaps six million pounds in today's prices. Most prized were the rare, striped, tulips. The exceptionally rare red and white 'Semper Augustus' bulb was valued at 1,000 florins in 1623, rising to 1,200 florins the following year. By 1625 the asking price had more than doubled and by 1633 5,500 florins were being demanded. At the height of tulipomania it had reached 10,000 florins and the highest price known to have been quoted, in 1638, was 13,000 florins for a single bulb, more than the cost of one of the most expensive houses on the canal at the centre of Amsterdam (10,000 florins).

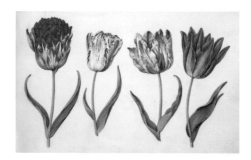

38. Hans Simon Holtzbecker (d. 1671), *Tulips*.
Watercolour, Germany, 1660.

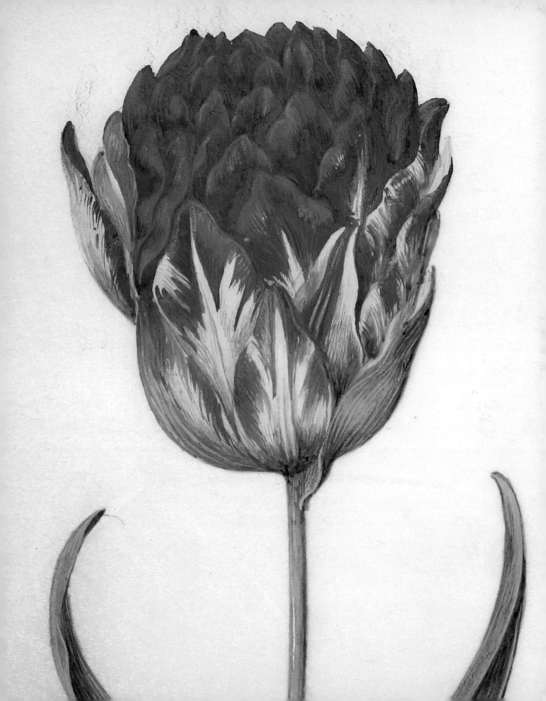

39. *County Flowers of the British Isles*

ENGLAND:
Bedfordshire *Bee orchid*
Berkshire *Summer snowflake (Loddon lily)*
Birmingham *Foxglove*
Bristol *Maltese-Cross (Flower of Bristol)*
Buckinghamshire *Chiltern gentian*
Cambridgeshire *Pasqueflower*
Cheshire *Cuckooflower (lady's smock)*
Cornwall/Kernow *Cornish heath*
Cumberland *Grass-of-Parnassus*
Derbyshire *Jacob's-ladder*
Devon *Primrose*
Dorset *Dorset heath*
Durham *Spring gentian*
Essex *Poppy*
Gloucestershire *Daffodil (wild)*
Hampshire *Dog-rose*
Herefordshire *Mistletoe*
Hertfordshire *Pasqueflower*
Huntingdonshire *Water-violet*
Isle of Wight *Pyramidal orchid*
Isles of Scilly *Thrift*
Kent *Hop*
Lancashire *Red Rose*
Leeds *Bilberry*
Leicestershire *Foxglove*
Lincolnshire *Common dog-violet*
Liverpool *Sea-holly*
London *Rosebay willowherb*
Manchester *Common cotton-grass*
Middlesex *Wood anemone*
Newcastle-upon-Tyne *Monkeyflower*
Norfolk *Poppy*
Northamptonshire *Cowslip*
Northumberland *Bloody crane's bill*

Nottingham *Nottingham catchfly*
Nottinghamshire *Autumn crocus*
Oxfordshire *Fritillary*
Rutland *Clustered bellflower*
Sheffield *Woodcrane's bill*
Shropshire *Round-leaved sundew*
Somerset *Cheddar pink*
Staffordshire *Heather*
Suffolk *Oxlip*
Surrey *Cowslip*
Sussex *Round-headed rampion*
Warwickshire *Honeysuckle*
Westmorland *Alpine forget-me-not*
Wiltshire *Burnt orchid*
Worcestershire *Cowslip*
Yorkshire *Harebell*

ISLE OF MAN: *Fuchsia*

NORTHERN IRELAND:
Antrim *Harebell*
Armagh *Cowbane*
Belfast *Gorse*
Derry *Purple saxifrage*
Down *Spring squill*
Fermanagh *Globeflower*
Tyrone *Bog-rosemary*

SCOTLAND:
Aberdeenshire *Bearberry*
Angus/Forfarshire *Alpine catchfly*
Argyll *Foxglove*
Ayrshire *Green-winged orchid*
Banffshire *Dark-red helleborine*
Berwickshire *Rock-rose*

Bute *Thrift*
Caithness *Scots primrose*
Clackmannanshire *Opposite-leaved golden-saxifrage*
Cromarty *Spring cinquefoil*
Dumfriesshire *Harebell*
Dunbartonshire/Dumbartonshire *Lesser water-plantain*
East Lothian/Haddingtonshire *Viper's-bugloss*
Edinburgh *Sticky catchfly*
Fife *Coralroot orchid*
Glasgow *Broom*
Inverness-shire *Twinflower*
Kinross *Holy-grass*
Kirkcudbright *Bog-rosemary*
Lanarkshire *Dune helleborine*
Midlothian/Edinburghshire *Sticky catchfly*
Moray *One-flowered wintergreen (St Olaf's candle-stick)*
Nairn *Chickweed wintergreen*
Orkney *Alpine bearberry*
Peeblesshire *Cloudberry*
Perthshire *Alpine gentian*
Renfrewshire *Bogbean*
Ross *Bog asphodel*
Roxburghshire *Maiden pink*
Selkirkshire *Mountain pansy*

Shetland *Shetland mouse-ear*
Stirlingshire *Scottish dock*
Sutherland *Grass-of-Parnassus*
West Lothian/ Linlithgowshire *Common spotted-orchid*
Western Isles *Hebridean spotted-orchid*
Wigtownshire *Yellow iris*

WALES:
Anglesey *Spotted rock-rose*
Brecknockshire *Cuckooflower (lady's smock)*
Caernarvonshire *Snowdon lily*
Cardiff *Wild leek*
Cardiganshire *Bog-rosemary*
Carmarthenshire *Whorled caraway*
Denbighshire *Limestone woundwort*
Flintshire *Bell Heather*
Glamorgan *Yellow whitlowgrass*
Merioneth *Welsh poppy*
Monmouthshire *Foxglove*
Montgomeryshire *Spiked speedwell*
Pembrokeshire *Thrift*
Radnorshire *Radnor lily*
PLANTLIFE INTERNATIONAL

40. Hans Simon Holtzbecker (d. 1671), *Frontispiece* (detail). Watercolour, Germany, 1660.

41. *Sunflower*

Sunflower, flower of shields
spins around, rich, sweet-smelling
flower. It's in our hands
here, by the shimmering water,
in a plain flowing like water with men,
the god will pick them, flowers.

Translated by Edward Kissam and Michael Schmidt
Aztec (Nahuatl)

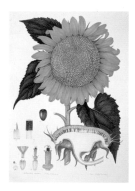

42. Margaret Stones (b. 1920),
Helianthus annus (Sunflower).
Watercolour, Australia, 1973.

46

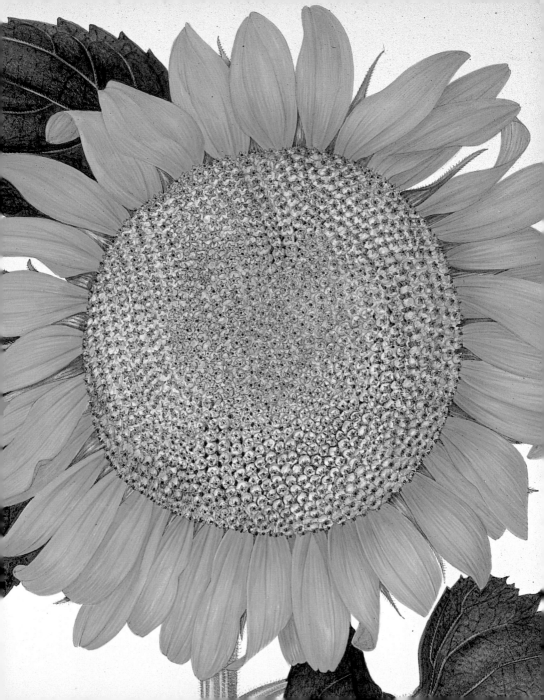

43. *Things to Remember*

The buttercups in May,
The wild rose on the spray,
The poppy in the hay,

The primrose in the dell,
The freckled foxglove bell,
The honeysuckle's smell

Are things I would remember
When cheerless, raw November
Makes room for dark December.

JAMES REEVES (1909–78)

44. Maxwell Armfield (1881–1972),
Primrose plant. Watercolour.

45. *To maystres Margaret Hussey*

Mirry Margaret,
As mydsomer flowre,
Ientill as fawcoun
Or hawke of the towre;
 With solace and gladnes,
Moche mirthe and no madnes,
All good and no badnes,
So ioyously,
So maydenly,
So womanly
Her demenyng
In every thynge,
Far, far passynge
That I can endyght,
Or suffyce to wryght
Of mirry Margarete,
As mydsomer flowre,
Ientyll as fawcoun

Or hawke of the towre;
 As pacient and as styll,
And as full of good wyll,
As fayre Isaphill;
Colyaunder,
Swete pomaunder,
Good cassaunder;
Stedfast of thought,
Wele made, wele wrought;
Far may be sought
Erst that ye can fynde
So corteise, so kynde
As mirry Margarete,
This midsomer flowre,
Ientyll as fawcoun
Or hawke of the towre.

JOHN SKELTON (*c.* 1460–1529)

46. Maria Sibylla Merian (1647–1717),
Lilium superbum. Watercolour, Germany.

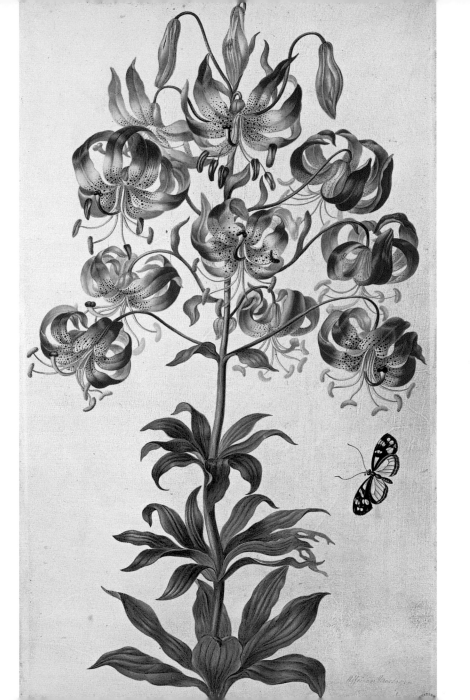

47. From *Poems in Praise of Practically Nothing*

You buy some flowers for your table;
You tend them tenderly as you're able;
You fetch them water from hither and thither –
What thanks do you get for it all? They wither.

SAMUEL HOFFENSTEIN (1890–1947)
USA

48. Charles Rennie Mackintosh (1868–1928),
Mixed Flowers, Mont Louis.
Watercolour, painted in France, 1925.

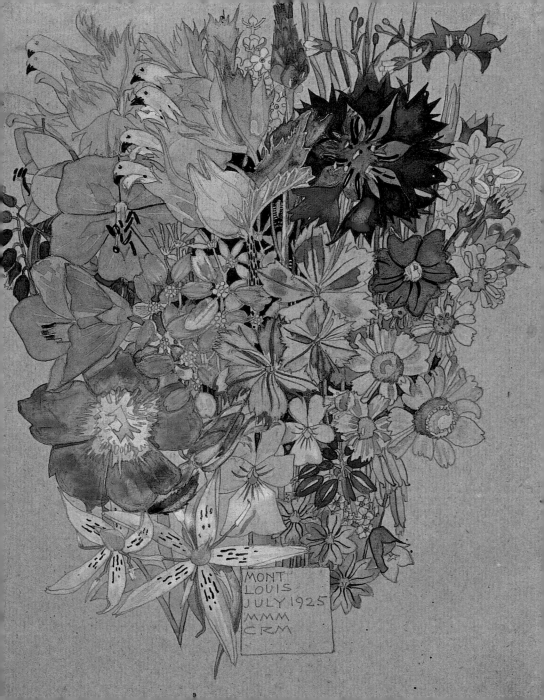

MONT
LOUIS
JULY 1925
MMM
CRM

49. *Giant Decorative Dahlia*

It is easy enough to love flowers but these
had never appealed to me before, so
out of proportion above my garden's
other coloured heads and steady stems.

This spring though, in warm soil, I set
an unnamed tuber, offered cheap, and,
when August came and still no sign,
assumed the slugs had eaten it.

 Suddenly it showed;
began to grow, became a small tree.
It was a race between the dingy bud
and the elements. It has beaten
the frost, rears now three feet above
the muddled autumn bed, barbaric petals
pink quilled with tangerine, turning
its great innocent face towards me
triumphantly through the damp afternoon.

I could not deny it love if I tried.

MOLLY HOLDEN (1927–81)

50. John Farleigh (1900–65),
Cactus Dahlia.
Wood engraving, 1949.

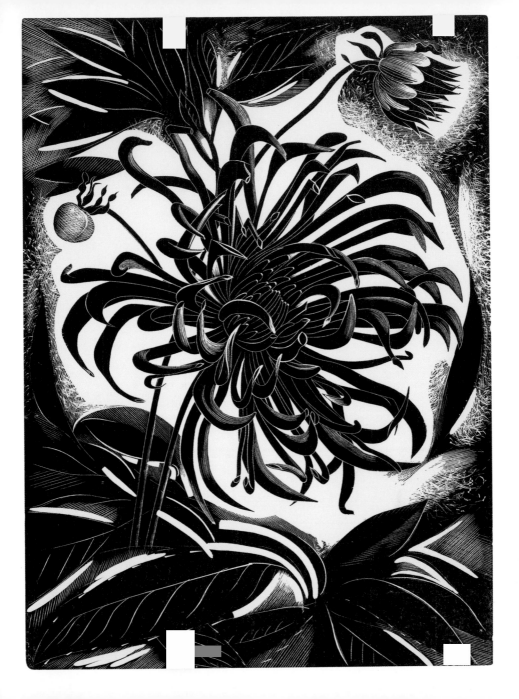

51. *Marigolds*

With a fork drive Nature out,
 She will ever yet return;
Hedge the flower bed all about,
 Pull or stab or cut or burn,
 She will ever yet return.

Look: the constant marigold
 Springs again from hidden roots.
Baffled gardener, you behold
 New beginnings and new shoots
 Spring again from hidden roots,
 Pull or stab or cut or burn,
 They will ever yet return.

Gardener, cursing at the weed,
 Ere you curse it further, say:
Who but you planted the seed
 In my fertile heart, one day?
 Ere you curse me further, say!
 New beginnings and new shoots
 Spring again from hidden roots.
 Pull or stab or cut or burn,
 Love must ever yet return.

ROBERT GRAVES (1895–1985)

52. Jacques Le Moyne (*c.* 1533–88),
French marigold and green veined butterfly.
Watercolour, France.

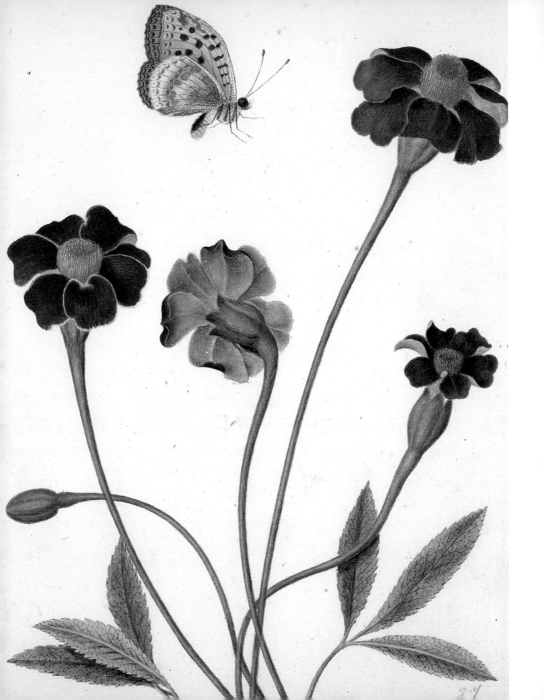

53. *A White Rose*

The red rose whispers of passion,
 And the white rose breathes of love;
Oh, the red rose is a falcon,
 And the white rose is a dove.

But I send you a cream-white rosebud
 With a flush on its petal tips;
For the love that is purest and sweetest
 Has a kiss of desire on the lips.

JOHN BOYLE O'REILLY (1844–90)
Ireland

54. Jan van Huysum (1682–1749),
Pink and white roses.
Watercolour, Netherlands.

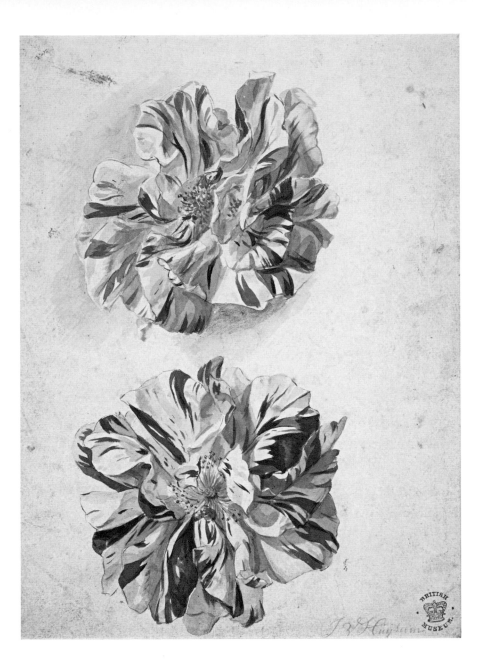

55. *A Gond Song*

Blossom is in her hair
Beautiful is it as the plantain flower
Some flowers bloom in the dawning
Some flowers bloom at the dead of night
The flower of holiness
Blooms in the morning and in the evening
At midnight blooms the flower of sin.

Translated by H.V.H. Elwin and Sām-Rāu Hivāle
India (Gond)

56. François Lemoyne (1688–1737),
Head of the Goddess Hebe.
Pastel over chalk on blue paper, France.

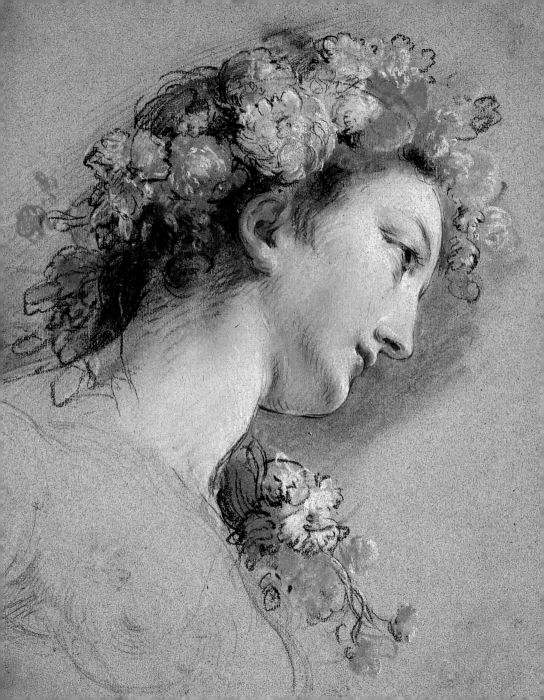

57. *Autumn Chrysanthemums*

Kokoro ate ni orabaya oran hatsu shimo no
Oki madowaseru shira giku no hana.

The year's first frost this morning fell,
 And I who seek some flowers white
Of my chrysanthemums can't tell
 The blossom from the rime aright.

OSHIKOCHI-NO MITSUNE (*fl. c.* 900 AD)
translated by H.H. Honda
Japan

58. Katsushika Hokusai (1760–1849),
Chrysanthemum and Bee. Woodblock, Japan.

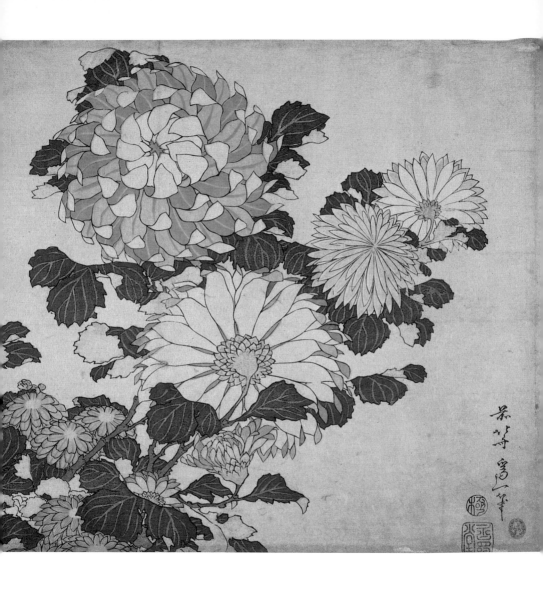

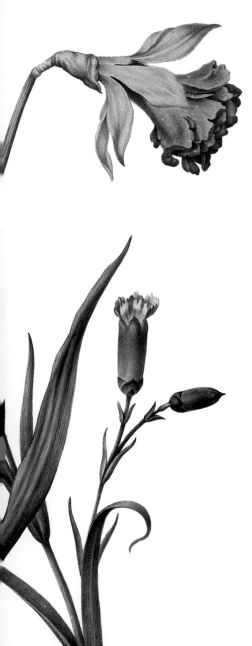

59. *Love Letters made of Flowers*

An exquisite invention this
Worthy of Love's most honied kiss,
This art of writing *billet-doux*
In buds, and odours, and bright hues!
Of saying all one feels and thinks
In clever daffodils and pinks;
In puns of tulips; and in phrases,
Charming for their truth, of daisies;
Uttering, as well as silence may,
The sweetest words the sweetest way.
How fit too for the lady's bosom!
The place where *billet-doux* repose 'em.

What delight, in some sweet spot
Combining *love* with *garden* plot,
At once to cultivate one's flowers
And one's epistolary powers!
Growing one's own choice words and
 fancies
In orange tubs, and beds of pansies;
One's sighs and passionate declarations
In odorous rhetoric of carnations;
Seeing how far one's stocks will reach;
Taking due care one's flowers of speech
To guard from blight as well as bathos,
And watering, every day, one's pathos!

A letter comes, just gathered. We
Dote on its tender brilliancy;
Inhale its delicate expressions
Of balm and pea, and its confessions
Made with as sweet a *Maiden's Blush*
As ever morn bedewed on bush,
('Tis in reply to one of ours,
Made of the most convincing flowers,)
Then after we have kissed its wit
And heart, in water putting it,
(To keep its remarks fresh,) go round
Our little eloquent plot of ground,
And with enchanted hands compose
Our answer, all of lily and rose,
Of tuberose and of violet,
And *Little Darling* (Mignonette)
Of *Look at me* and *Call me to you*,
(Words that while they greet, go through you),
Of *Thoughts*, of *Flames*, *Forget-me-not*,
Bridewort, — in short, the whole blest lot
Of vouchers for a life-long kiss,
And literally, breathing bliss.

LEIGH HUNT (1784–1859)

60. Attributed to Nicolas Robert (1614–84),
Carnation, tulip, double daffodil (details).
Watercolour, France.

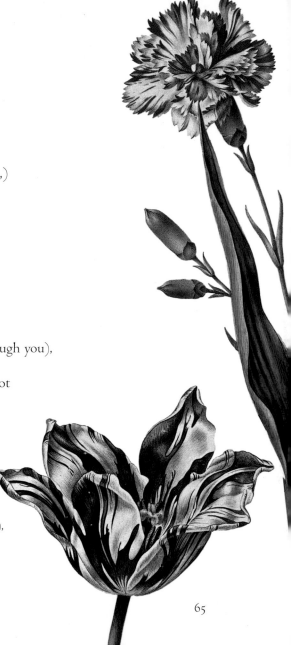

61. From *The Rubáiyát of Omar Khayyám*

Alas, that Spring should vanish with the Rose!
That Youth's sweet-scented Manuscript should close!
 The Nightingale that in the Branches sang,
Ah, whence, and whither flown again, who knows!

Ah Love! could thou and I with Fate conspire
To grasp this sorry Scheme of Things entire,
 Would not we shatter it to bits — and then
Re-mould it nearer to the Heart's Desire!

Ah, Moon of my Delight who know'st no wane,
The Moon of Heav'n is rising once again:
 How oft hereafter rising shall she look
Through this same Garden after me — in vain!

And when Thyself with shining Foot shall pass
Among the Guests Star-scatter'd on the Grass,
 And in thy joyous Errand reach the Spot
Where I made one — turn down an empty Glass!

OMAR KHAYYÁM (*c.* 1048–1122),
translated by Edward FitzGerald (1809–83)
Iran

62. Unknown artist, *Bird and flowers.*
Opaque watercolour on paper,
Qajar Iran, mid-nineteenth century.

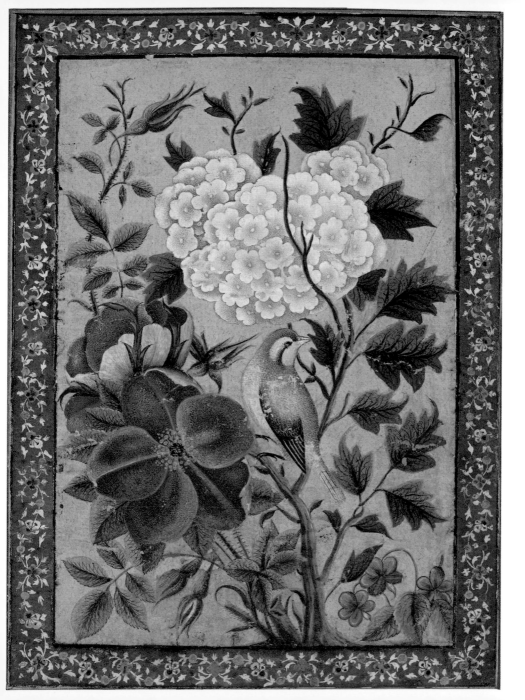

63. *Bavarian Gentians*

Not every man has gentians in his house
in soft September, at slow, sad Michaelmas.

Bavarian gentians, big and dark, only dark
darkening the day-time, torch-like with the smoking blueness of
 Pluto's gloom,
ribbed and torch-like, with their blaze of darkness spread blue
down flattening into points, flattened under the sweep of white day
torch-flower of the blue-smoking darkness, Pluto's dark-blue daze,
black lamps from the halls of Dis, burning dark blue,
giving off darkness, blue darkness, as Demeter's pale lamps give off
 light,
lead me then, lead the way.

Reach me a gentian, give me a torch!
let me guide myself with the blue, forked torch of this flower
down the darker and darker stairs, where blue is darkened on blueness.
even where Persephone goes, just now, from the frosted September
to the sightless realm where darkness is awake upon the dark
and Persephone herself is but a voice
or a darkness invisible enfolded in the deeper dark
of the arms Plutonic, and pierced with the passion of dense gloom,
among the splendour of torches of darkness, shedding darkness on
 the lost bride and her groom.

D.H. LAWRENCE (1885–1930)

64. Mary Delany (1700–88),
Gentian. Paper collage, 1780.

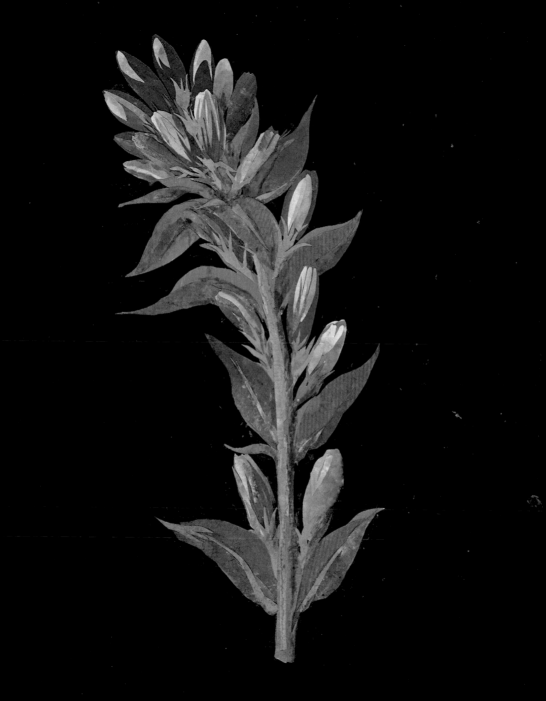

65. *To Hsü Shih-t'ing*

I hear that the peonies are magnificent
 in the famous gardens now
and that rich families will be enjoying them
 until spring is almost gone.
What a shame! I too am a man who loves to look at flowers
but I am much too busy, watering my vegetable patch.

HSÜ WEI (1521–93)
translated by Jonathan Chaves
China

66. Enamelled porcelain saucer, *Cock and peony flowers.*
China, Qing dynasty, 1723–35.

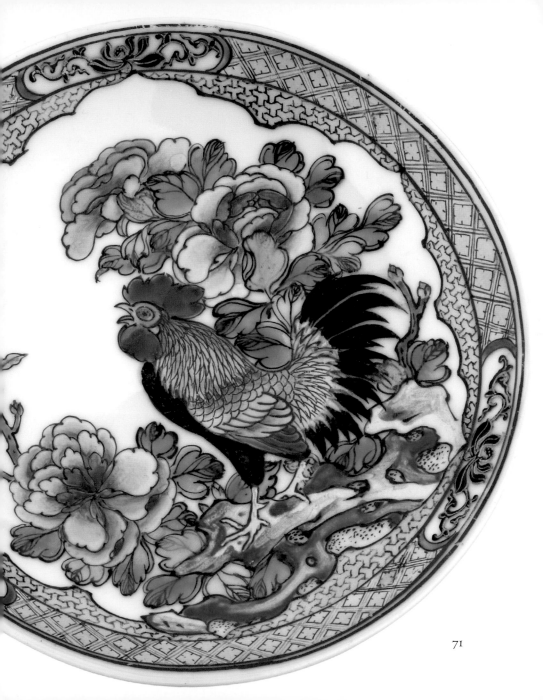

67. From *The Legend of Good Women*

> And as for me, though that I konne but lyte,
> On bokes for to rede I me delyte,
> And to hem yive I feyth and ful credence,
> And in myn herte have hem in reverence
> So hertely, that ther is game noon
> That fro my bokes maketh me to goon,
> But yt be seldom on the holyday,
> Save, certeynly, whan that the month of May
> Is comen, and that I here the foules synge,
> And that the floures gynnen for to sprynge,
> Farewel my bok, and my devocioun!
> Now have I thanne eek this condicioun
> That, of al the floures in the mede,
> Thanne love I most thise floures white and rede,
> Swiche as men callen daysyes in our toun.
> To hem have I so gret affeccioun,
> As I seyde erst, whanne comen is the May,
> That in my bed ther daweth me no day
> That I nam up and walkying in the mede
> To seen this flour ayein the sonne sprede,
> Whan it upryseth erly by the morwe.
> That blisful sighte softneth al my sorwe,
> So glad am I, whan that I have presence
> Of it, to doon it alle reverence,
> As she that is of alle floures flour,
> Fulfilled of al vertu and honour,
> And evere ilyke faire, and fressh of hewe;
> And I love it, and ever ylike newe,
> And evere shal, til that myn herte dye.

GEOFFREY CHAUCER (*c.* 1340–1400)

68. Jacques Le Moyne
(*c.* 1533–88), *Double daisy.*
Watercolour, France.

69. *Formula for taking the form of a lotus*

I am that pure lotus that comes forth from light,
　　Who is at the nostril of Ra.
I made my descent. I sought him out for Horus.
I am the pure one who comes forth from the marshes.

BOOK OF THE DEAD, Papyrus of Nu,
early eighteenth dynasty,
translated by Stephen Quirke
Egypt

70. The pool in the garden of Nebamun, a Theban official.
Tomb painting on plaster, Thebes, Egypt, *c.* 1350 BC.

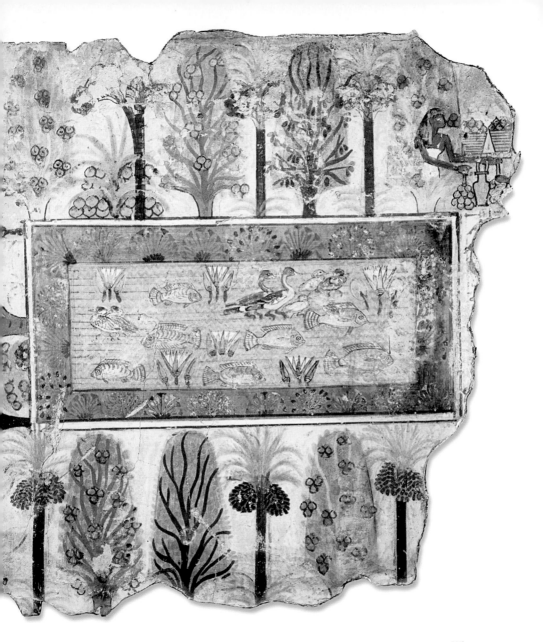

71. *Thistles*

Against the rubber tongues of cows and the hoeing hands of men
Thistles spike the summer air
Or crackle open under a blue-black pressure.

Every one a revengeful burst
Of resurrection, a grasped fistful
Of splintered weapons and Icelandic frost thrust up

From the underground stain of a decayed Viking.
They are like pale hair and the gutturals of dialects.
Every one manages a plume of blood.

Then they grow grey, like men.
Mown down, it is a feud. Their sons appear,
Stiff with weapons, fighting back over the same ground.

TED HUGHES (1930–98)

72. Margaretha Barbara Dietzsch (1716–95),
Thistle with butterflies and insects.
Watercolour, Germany.

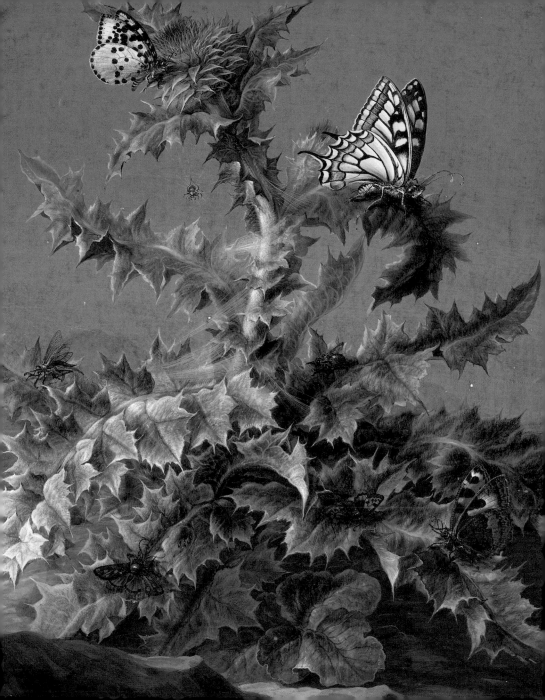

73. *Stage Directions for Bluebells*

OK. Everyone else off-stage —
we'll just have bluebells for this one.
Lilac? Don't fire your torches yet.
Daisies? Just stay folded, will you?
Now. Bluebells. Can we all be up-
standing? That's it. Spread yourselves
about a bit. Use the whole stage.
What d'you think we've got all this green
foliage for? Nice! Nice! Now families —
over on the right, please. And you two —
could you appear to be in conversation,
or at least on nodding acquaintance? No,
there's no need to be facetious. You don't
have to ring. Solitaries? Nestle in the shade
among the ferns and ivies. No, you can't
have extra lighting. It's contrast we're after.
OK. You shy, flirty ones — over by the wall.
Peep through the peonies. Can you tremble?
Very nice! Miss Precocious? By the rose.
Now. You extras. All right, all righty,
individuals. We're running out of space here.
Do what you can with the cracks in the path.
Yes, I realize you might get trampled on —
that's just a risk you've got to take.
Lovely! Lovely! You all look very picturesque.
OK. That's it! Hold it! Hold it!
We'll call it 'Late April in England, with
 bluebells.'

DIANA HENDRY (b. 1941)

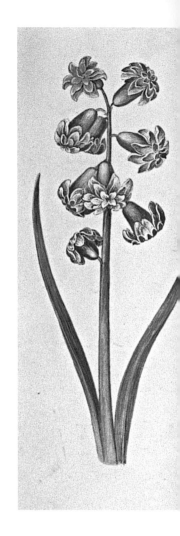

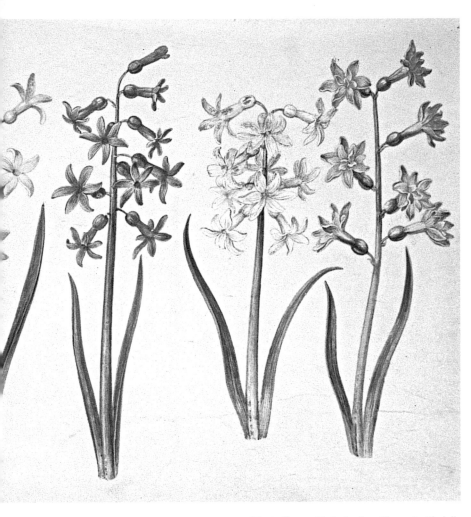

74. Hans Simon Holtzbecker (d. 1671), *Bluebells*.
Watercolour, Germany, 1660.

75. *Retreat*

Broken, bewildered by the long retreat
Across the stifling leagues of Southern plain,
Across the scorching leagues of trampled grain,
Half-stunned, half-blinded by the trudge of feet
And dusty smother of the August heat,
He dreamt of wild flowers in an English lane,
Of hedgerow flowers aglisten after rain –
All-heal and willowherb and meadowsweet.

All-heal and willowherb and meadowsweet –
The innocent names kept up a cool refrain,
All-heal and willowherb and meadowsweet,
Chiming and tinkling through his aching brain
Until he babbled as a child again –
All-heal and willowherb and meadowsweet.

WILFRID WILSON GIBSON (1878–1962)

76. Mary Delany (1700–88),
Meadowsweet.
Paper collage, 1780.

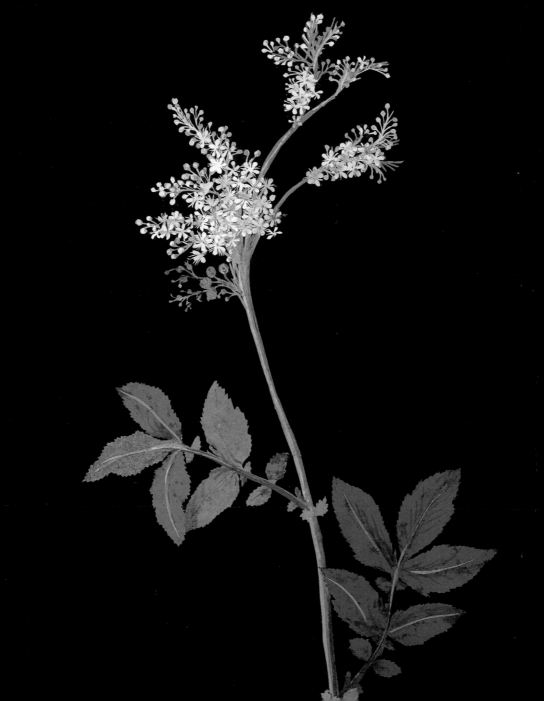

Roses ruddy and roses white,
 What are the joys that my heart discloses?
Sitting alone in the fading light
Memories come to me here to-night
 With the wonderful scent of the big red roses.

Memories come as the daylight fades
 Down on the hearth where the firelight dozes;
Flicker and flutter the lights and shades,
And I see the face of a queen of maids
 Whose memory comes with the scent of roses.

Visions arise of a scene of mirth,
 And a ball-room belle that superbly poses —
A queenly woman of queenly worth,
And I am the happiest man on earth
 With a single flower from a bunch of roses.

Only her memory lives to-night —
 God in His wisdom her young life closes;
Over her grave may the turf be light,
Cover her coffin with roses white —
 She was always fond of the big white roses.

Such are the visions that fade away —
 Man proposes and God disposes;
Look in the glass and I see to-day
Only an old man, worn and grey,
 Bending his head to a bunch of roses.

A.B. 'BANJO' PATERSON (1864–1941), Australia

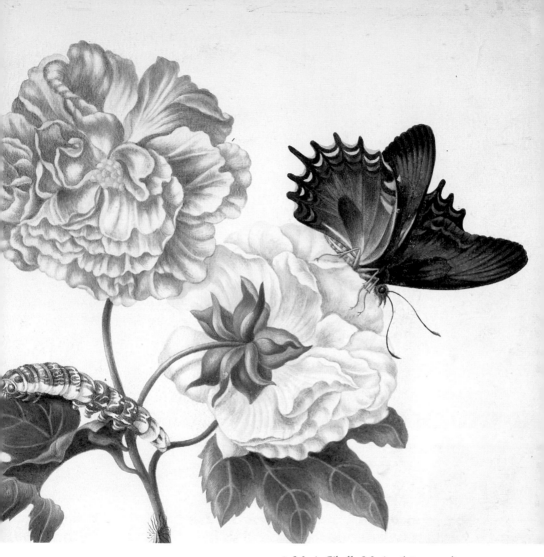

78. Maria Sibylla Merian (1647–1717),
Pink and white roses and butterflies (detail).
Watercolour, Germany.

79. *The Smell of Chrysanthemums*

The chestnut leaves are toasted. Conkers spill
Upon the pavements. Gold is vying with
Yellow, ochre, brown. There is a feel
Of dyings and departures. Smoky breath
 Rises and I know how Winter comes
 When I can smell the rich chrysanthemums.

It is so poignant and it makes me mourn
For what? The going year? The sun's eclipse?
All these and more. I see the dead leaves burn
And everywhere the Summer lies in heaps.
 I close my eyes and feel how Winter comes
 With acrid incense of chrysanthemums.

I shall not go to school again and yet
There's an old sadness that disturbs me most.
The nights come early; every bold sunset
Tells me that Autumn soon will be a ghost,
 But I know best how Winter always comes
 In the wide scent of strong chrysanthemums.

ELIZABETH JENNINGS (1926–2001)

80. Kano Morimasa Tanshin (1653–1718),
Toemmei (Tao Yuanming) admiring the chrysanthemums.
Kakemono painting, Japan.

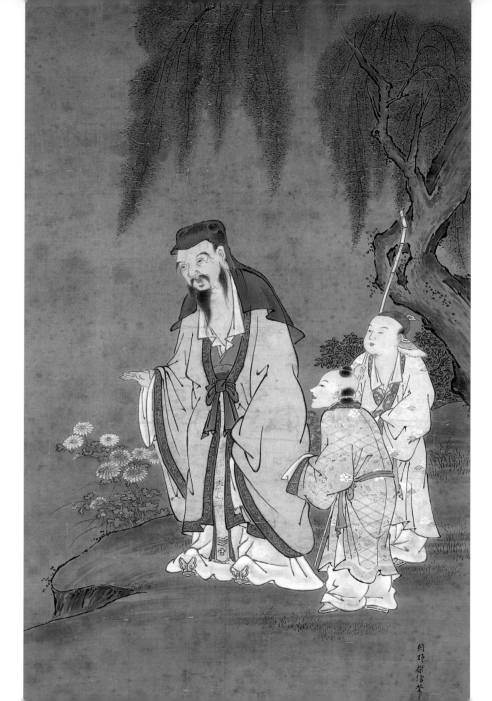

81. *I Expect an Orchid*

Sometimes today
I am an old tree
discolouring
growing fungus
spreading slowly on my bark
a pink filigree, reaching slowly –
I cast no seeds.

But
I expect an orchid
to grow out of the pool
of one eye, though
Aged lianas coil around my
 neck
blocking my forests
Grow long in tendons
in my arms, and legs
and one day, slowly, slowly
will root me
subsiding silently
to the earth

Till then, I dance, slowly, slowly
turning, still turning
from my grave
of space
still hoping, again
ever hoping, once more
to fly …
Since
I expect an orchid, any day, now …

MARINA AMA OMOWALE
MAXWELL (b. 1934)
Trinidad and Tobago

82. Unknown artist,
Orchid (Dendrobium Parishii).
Painted on mica,
India, mid-nineteenth century.

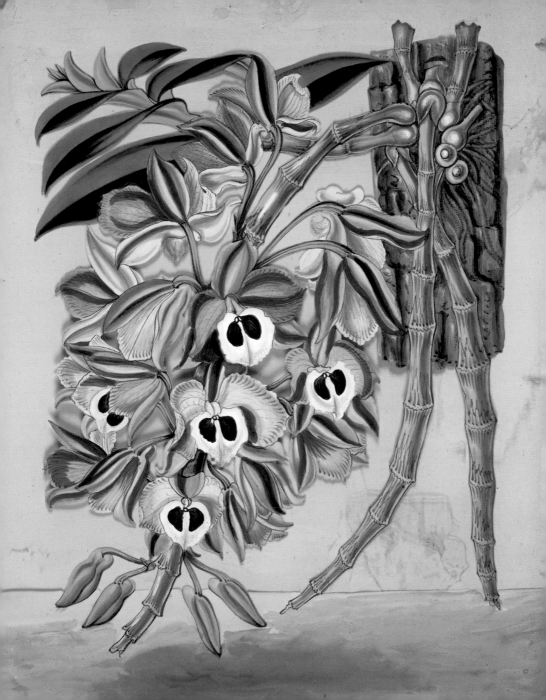

83. *Daffodils*

I wandered lonely as a cloud
That floats on high o'er vales and hills,
When all at once I saw a crowd,
A host, of golden daffodils;
Beside the lake, beneath the trees,
Fluttering and dancing in the breeze.

Continuous as the stars that shine
And twinkle on the milky way,
They stretched in never-ending line
Along the margin of a bay:
Ten thousand saw I at a glance,
Tossing their heads in sprightly dance.

The waves beside them danced; but they
Out-did the sparkling waves in glee:
A poet could not but be gay,
In such a jocund company:
I gazed – and gazed – but little thought
What wealth the show to me had brought:

For oft, when on my couch I lie
In vacant or in pensive mood,
They flash upon that inward eye
Which is the bliss of solitude;
And then my heart with pleasure fills,
And dances with the daffodils.

WILLIAM WORDSWORTH (1770–1850)

84. Jacques Le Moyne (*c.* 1533–88),
Wild Daffodils (detail).
Watercolour, France.

88

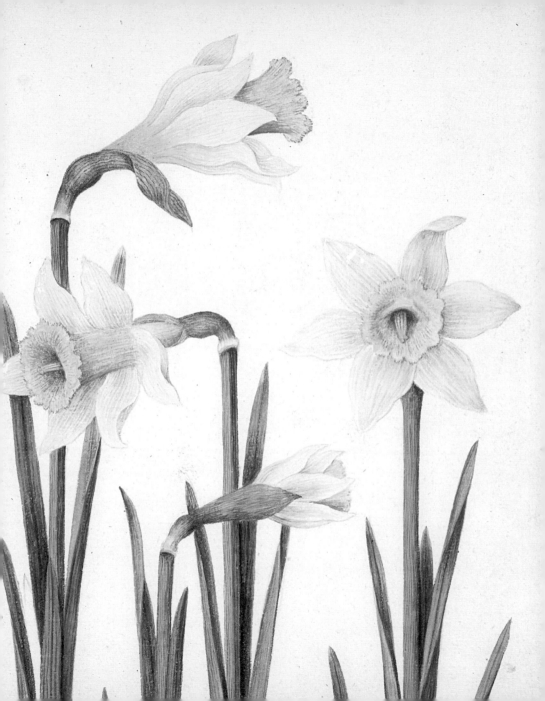

85. *Inscription in a Garden*

If any floure that here is growne,
 Or any hearbe may ease your payne,
Take and accompte it as your owne,
But recompence the lyke agayne:
For some and some is honest playe,
And so my wyfe taughte me to saye.

 If here to walke you take delight,
Why come, and welcome when you will:
If I bidde you suppe here this night,
Bidde me an other time, and still
Thinke some and some is honest playe,
For so my wife taught me to saye.

 Thus if you suppe or dine with mee,
If you walke here, or sitte at ease,
If you desire the thing you see,
And have the same your minde to please,
Thinke some and some is honest playe,
And so my wife taught me to saye

GEORGE GASCOIGNE (1534/5?–77)

86. Joshua Cristall (*c.* 1767–1847),
Cottage at St Lawrence, Isle of Wight.
Watercolour, 1814.

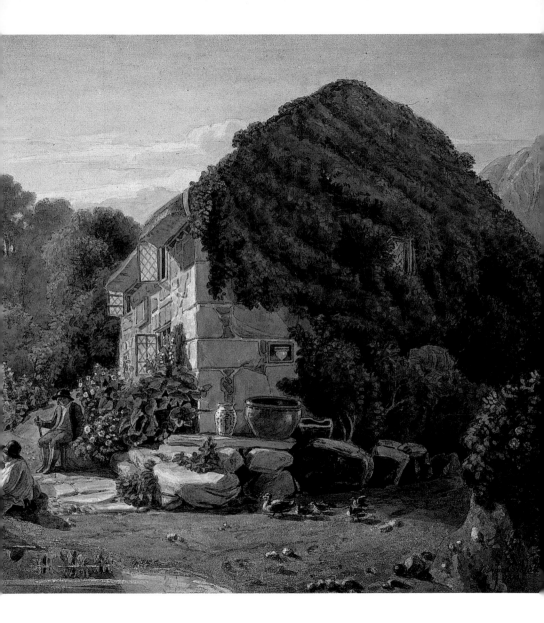

91

NOTES ON THE TEXT
AND ILLUSTRATIONS

Frontispiece: PD 1994-6-18-1.

Title page: From 'Song of the Flowers' in *The Poetical Works of Leigh Hunt*, ed. H.S. Milford, Oxford University Press, London, 1923.

1. From *The Gardener*, No. 85, Macmillan & Co. Limited, London, 1913. Freely translated by the author from the original Bengali. © Professor Swapan Majumdar.

2. Asia 1969.3-17.0.1. Given by Mr and Mrs Anthony N. Stuart.

3. Act 3, scene i.

4. PD SL. 5284.24.

5. From *The Collected Poems of William Carlos Williams*, Volume II, 1939–1962, ed. Christopher MacGowan, Carcanet Press Limited, Manchester, 1988 (poem first published in *Pictures from Brueghel*, 1962). Reproduced by permission of Carcanet Press Limited, Manchester.

6. PD SL. 5283.182.

7. From *Mother Love* by Rita Dove. Copyright © 1995 by Rita Dove. Used by permission of the author and W.W. Norton & Company, Inc.

8. JA 2004.3-30.0.11. Narcissus Field near Kochomon, Echizen Coast, Fukui Prefecture. Given by the artist. Reproduced by kind permission of the artist. © Kiyota Yuji.

9. From *The Cabinet edition of The British Poets*, vol. 2, Henry G. Bohn, London, 1851.

10. PD 1962-7-14-1 (13).

11. From *Collected Poems*, Cassell & Company Ltd, 1975. Reproduced by permission of Carcanet Press Limited, Manchester.

12. PD 1949-4-11-3576. Sheet of studies, bequeathed by Campbell Dodgson.

13. From *The Works of Alfred Lord Tennyson, Poet Laureate*, Macmillan & Co. Limited, London, 1905 (poem written about 1860, first published in 1889).

14. PD 1897-5-5-346, Vol. iv, 45. Mrs Delany's paper collages were made between 1772 and 1782, mostly at her London home or at Bulstrode, Buckinghamshire, the home of the Duchess of Portland. A collection of 985 collages was bequeathed to the British Museum by a member of her family, Lady Llanover.

15. From *The Old Garden and Other Verses*, Houghton, Mifflin & Company, Boston and New York, 1886.

16. PD 1885-5-9-47.

17. From *Enough Rope: Poems by Dorothy Parker*, Boni and Liveright, New York, 1926 (poem first

published in *Life*, 13, 4 January 1923). Reproduced by permission of Pollinger Limited and the artist's estate.

18. PD 1888-12-11-1 (67). From an album with 73 vellum leaves of botanical drawings painted by Hans Simon Holzbecker of Hamburg and inscribed *Holtzbecker, pictor* and *Anno 1660*.

19. From *The Poetical Works of Leigh Hunt*, ed. H.S. Milford, Oxford University Press, London, 1923 (poem first published in 'The New Monthly Magazine', May 1836, reprinted 1844–60).

20. PD 1897-5-5-648, Vol. vii, 48.

21. From *Good Friday and other poems*, The Macmillan Company, New York, 1916. Reproduced by permission of the Society of Authors as the Literary Representative of the Estate of John Masefield.

22. PD 1895-9-15-986.

23. From *Bengali Poems on Calcutta*, selected and transcreated by Subhoranjan Dasgupta and Sudeshna Chakravarty, Writers' Workshop, Calcutta, 1972.

24. Asia 1948.10-9.0.147. Given by P.C. Manuk and G.M. Coles through the National Art Collections Fund.

25. St. Matthew, Chapter 6: 28–30.

26. PD SL. 5284.34.

27. From Edward G. Browne, *A History of Persian Literature under Tartar Dominion (AD 1265–1502)*, Cambridge University Press, 1920. From British Library manuscript Or.2847 f. 98a.

28. Asia 1948.2-11.0.8. Bequeathed by Sir Bernard Eckstein, Bt.

29. From *A Child's Garden of Verses*, 2nd edn, Longmans Green & Co., London, 1885.

30. PD 1962-7-14-1 (25).

31. From Act 2, scene i.

32. PD 1897-5-5-704, Vol. viii, 3.

33. From *The Dagonet Ballads (Chiefly from the "Referee")*, J.P. Fuller, London, 1881. The Varden hat and hose were named after the style of the coquettish Dolly Varden in Charles Dickens's *Barnaby Rudge*.

34. PD 1877-1-13-176.

35. From *Collected Poems by Edward Thomas*, Ingpen & Grant, London, 1928 (poem written in 1915, first published 1922). Thomas was killed at the battle of Arras.

36. PD 1977-1-22-1. © courtesy of the artist's estate. © Bridgeman Art Library.

37. For a detailed history of the tulip see Anna Pavord, *The Tulip*, Bloomsbury, London, 1999.

38. PD 1888-12-11-1 (10).

39. Reproduced by permission of Plantlife International. © Plantlife International, 2002. A charity dedicated to the conservation of wild plants in their natural habitats. Members of the public throughout the British Isles were invited to nominate a wild flower as an emblem for their county.

40. PD 1888-12-11-1 (2). Detail from a frontispiece which includes the arms of the Anckelmann family, for whom, presumably, the album was painted.

41. From *Flower and Song: Poems of the Aztec Peoples* translated by Edward Kissam and Michael Schmidt, published by Anvil Press Poetry, London, 1977. Nahuatl is a complex language with layers of symbolism. The word for 'flower' can symbolise the heart given in sacrifice, or the warrior's heart given in battle, or simply blood, the body's flower.

42. PD 1974-2-23-9.

43. From *Poems for Children*. *The Blackbird in the Lilac*, Oxford University Press, London, 1952.

44. PD 2003-6-1-54. © courtesy of the artist's estate. © Bridgeman Art Library. Given by David Brown in memory of Liza Brown.

45. From *The Poetical Works of John Skelton with notes and some account of the author and his writings by the Rev. Alexander Dyce*, vol. I, Thomas Rodd, London, 1843. One of a series of poems written in praise of the Countess of Surrey and her ladies.

46. PD SL. 5276.82.

47. From *Poems in Praise of Practically Nothing*, Jonathan Cape, London, 1929. Published by Liveright Publishing Corporation, New York. © 1928 by Samuel Hoffenstein. Reproduced by permission of Liveright Publishing Corporation, New York.

48. PD 1981-12-12-20.

49. From *To Make Me Grieve*, Chatto & Windus, London, 1968. © Alan Holden. Reproduced by kind permission of Alan Holden.

50. PD 1992-2-29-34. Reproduced by kind permission of Barbara Kane. © Artist's estate. Given by Mrs B.J. Kane.

51. From *Robert Graves: The Complete Poems in one volume*, eds Beryl Graves and Dunstan Ward, Carcanet Press Limited, Manchester, 2000. Reproduced by permission of Carcanet Press Limited, Manchester.

52. PD 1962-7-14-1.29.

53. From James Jeffrey Roche, *Life of John Boyle O'Reilly . . . together with his Complete Poems and Speeches, edited by Mrs John Boyle O'Reilly*, T. Fisher Unwin, London, 1891.

54. PD SL. 5283.150.

55. From *The Penguin Book of Oral Poetry*, ed. Ruth Finnegan, Allen Lane, London, 1978. Originally published in H.V.H. Elwin and Sām-Rāu Hivāle, *Folk Songs of the Maikal Hills*, Oxford University Press, Bombay, 1944. Reproduced by permission of Oxford University Press India, New Delhi. The Gonds, or Koyathor, as they call themselves, are an ethnic group of Dravidian speakers in Central India.

56. PD 1850-3-9-1.

57. From Fujiwara Sadaiye, *One Hundred Poems from One Hundred Poets, being a translation of the Ogura Hyaku-nin-isshiu* by H.H. Honda, The Hokuseido Press, Tokyo, 1956. This is a well-known

anthology of poems dating from the seventh to the thirteenth century AD, selected in the third decade of the thirteenth century.

58. JA 1927.5-18.0.6.

59. From *The Poetical Works of Leigh Hunt*, ed. H.S. Milford, Oxford University Press, London, 1923 (poem first published in Joseph Ablett's, *Literary Hours*, 1837, as 'An Albanian Love-Letter'). The language of flowers – a complex system of meanings attached to different flowers – was used as a half secret code in the nineteenth century.

60. PD SL. 5277.14.

61. From reprint of the 1st edition of 1859, Ward Locke & Co Limited, London, 1910.

62. Asia 1974.6-17.0.3.1.

63. From *D.H. Lawrence: The Complete Poems . . .*, eds Vivian de Sola Pinto and Warren Roberts, Penguin Books, 1977 (first published by The Viking Press, U.S.A., 1964). Reproduced by permission of Pollinger Limited and the estate of Frieda Lawrence Ravagli.

64. PD 1897-5-5-356, Vol. iv, 55.

65. From *The Columbia Book of Later Chinese poetry. Yuan, Ming, and Ch'ing Dynasties (1279–1911)*, translated and ed. by Jonathan Chaves. © 1986 Columbia University Press. Reprinted with permission of the publisher.

66. Asia Franks 705+. Given by Sir Augustus Wollaston Franks.

67. From The Prologue to *The Legend of Good Women*, in F.N. Robinson, ed., *The Complete Works of Geoffrey Chaucer*, Student's Cambridge Edition, Houghton Mifflin Company, Boston, 1933.

68. PD 1962-7-14-1 (21).

69. From Werner Forman and Stephen Quirke, *Hieroglyphs and the Afterlife in Ancient Egypt*, British Museum Press, 1996. © Opus Publishing Limited. Reproduced by kind permission of Stephen Quirke.

70. AES 37983.

71. From *Wodwo*, Faber & Faber Ltd, London, 1967 in *Ted Hughes, Collected Poems*, ed. Paul Keegan, Faber & Faber, London, 2003.

72. PD 1883-8-11-41.

73. From *Strange Goings-on*, Viking, London, 1995. Reproduced by kind permission of the author. © Diana Hendry.

74. PD 1888-12-11-1 (6).

75. From *Collected Poems 1905–1925*, Macmillan & Co., London, 1926 (poem first published 1916). Reproduced by permission of Pan Macmillan, London.

76. PD 1897-5-5-834, Vol. ix, 33.

77. From *The Man from Snowy River and other Verses*, Macmillan & Co. Limited, London, 1916 (first published in Sydney 1895).

78. PD SL. 5275.31.

79. From *A Spell of Words, Selected Poems for Children*, Macmillan Children's Books, London, 1997. Reproduced by permission of David Higham Associates Limited, London.

80. JA 1913.5-1.0.199. Collection made by Arthur Morrison, purchased and presented by Sir William Gwynne-Evans.

81. From *The Heinemann Book of Caribbean Poetry*, eds Ian McDonald and Stewart Brown, Heinemann, London, 1992. Reproduced by kind permission of the author. © Marina Ama Omowale Maxwell.

82. Asia 2003.2-22.0.22.

83. From 'Poems of the Imagination' in *The Poetical Works of William Wordsworth*, ed. Thomas Hutchinson, Henry Frowde, Oxford University Press Warehouse, London, 1895 (poem composed 1804, published 1807).

84. PD 1962-7-14-1 (5).

85. From *The Complete Poems of George Gascoigne now first collected and edited from the Early Printed Copies and from Manuscripts with a Memoir and Notes by William Carew Hazlitt*. Vol. I. Printed for the Roxburghe Library, 1869. The poem is taken from Seven Sonnets in sequence on a theme suggested to Gascoigne by Sir Alexander Nevil.

86. PD 1980-10-11-1.

ACKNOWLEDGEMENTS

Thanks are due to the following for their advice and assistance:
Isabel Andrews, Giulia Bartrum, Richard Blurton, Rosemary Bradley, Sheila Canby,
Allyson Carless, Tim Clark, Jill Cook, Margaret Fenn, Ivor Kerslake, Kevin Lovelock,
Colin McEwan, Jerome Perkins, Mavis Pilbeam, Jennifer Ramkalawon, Angela Roche,
Peter Ward, Beatriz Waters, Leslie Webster, John Williams and Sir David Wilson.